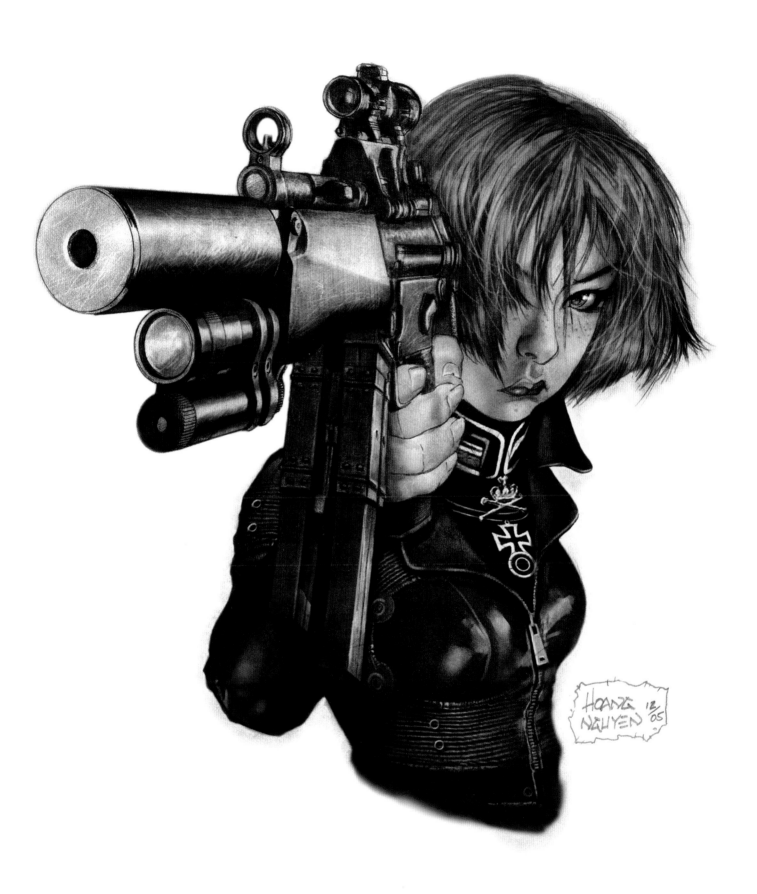

mememories lost-the art of hoang nguyen

first edition 2007

ISBN: 0-9787222-1-3

printed in colombia

co-published by
liquidbrush productions/brandstudio press
hoang@liquidbrush.com

www.liquidbrush.com
www.brandstudiopress.com

info@brandstudio.com

published by
brandstudio press
222-19 39th avenue
bayside, NY 11361
info@brandstudio.com

Memories Lost

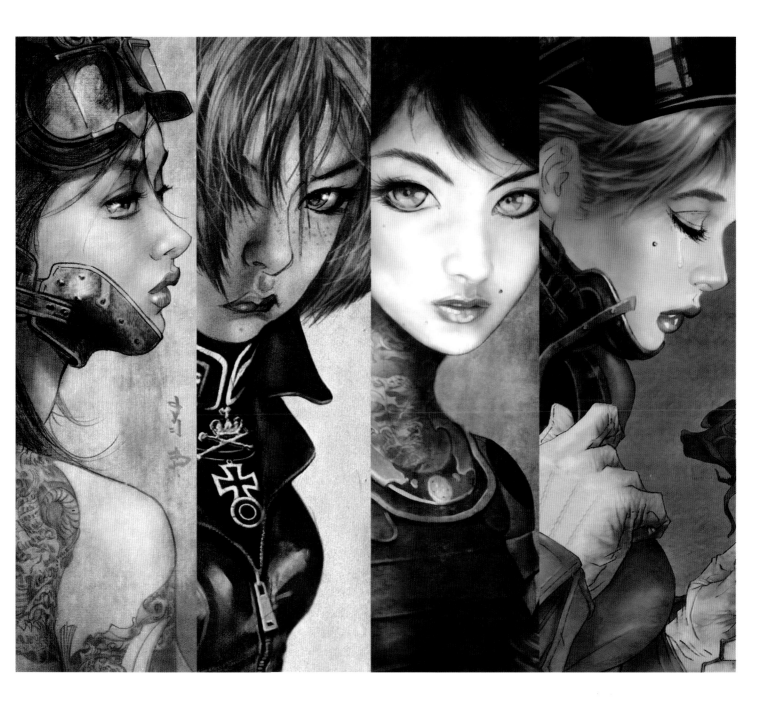

The Art of Hoang Nguyen

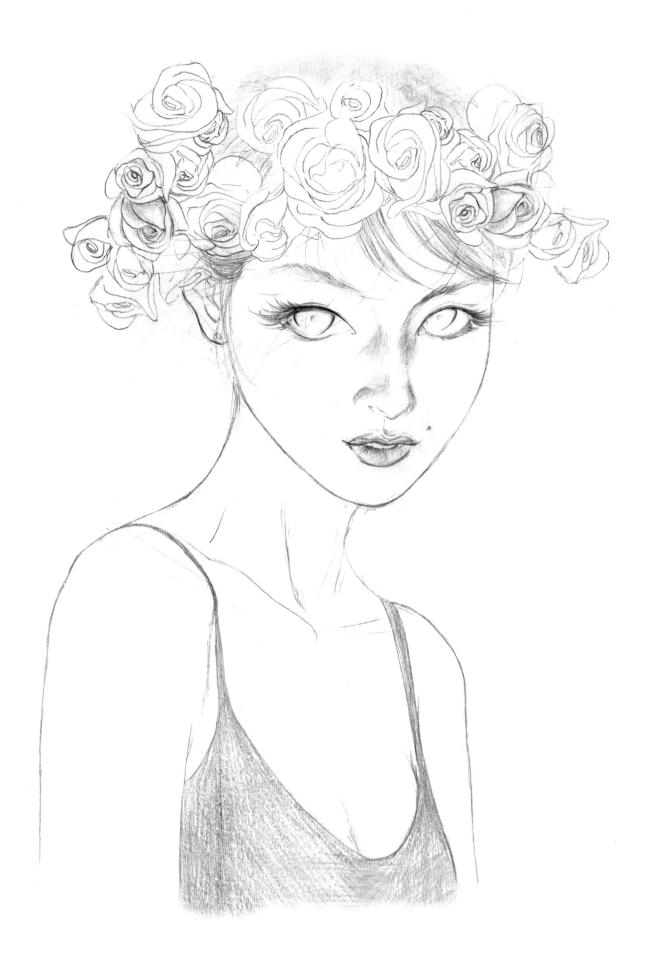

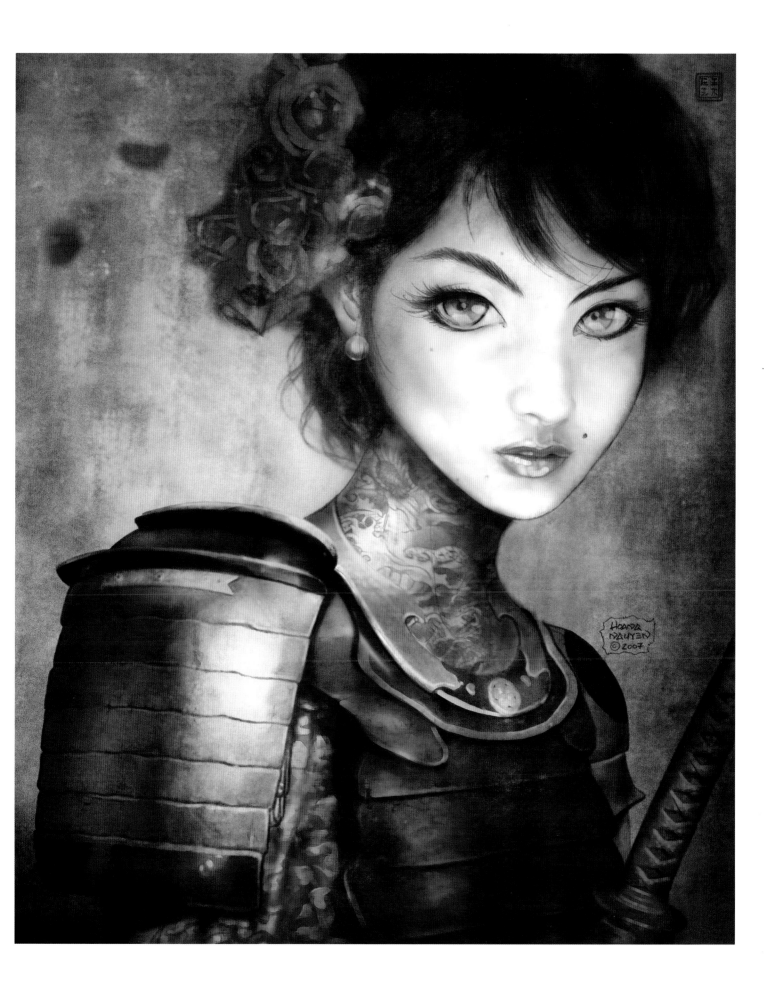

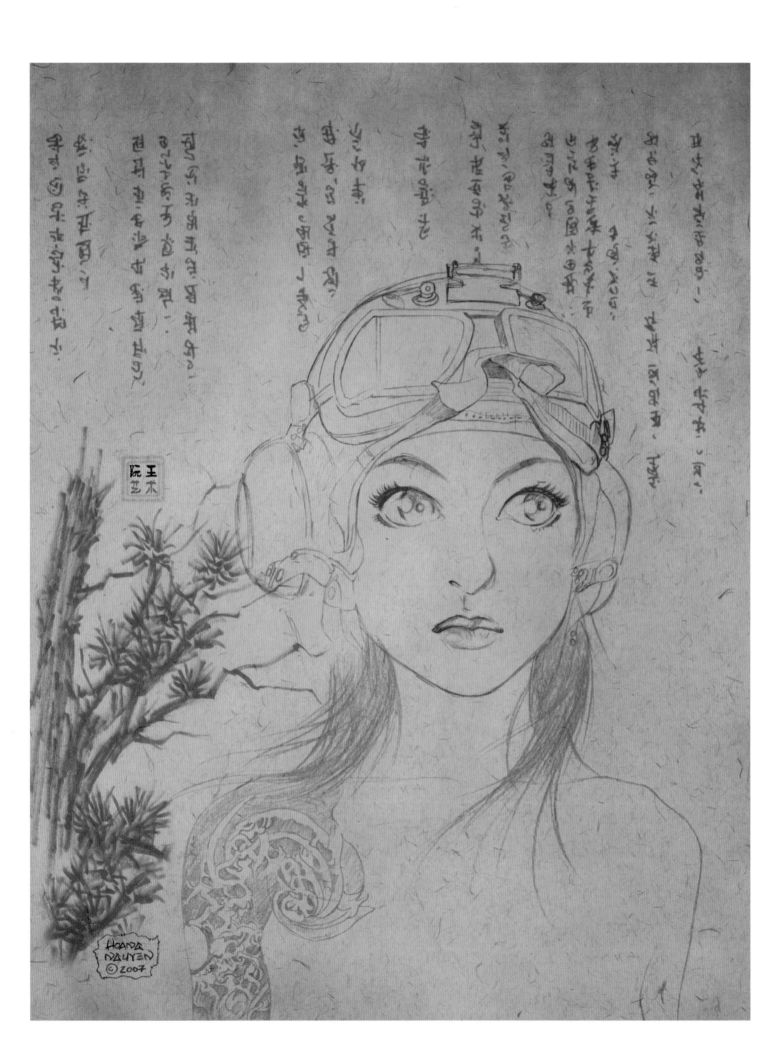

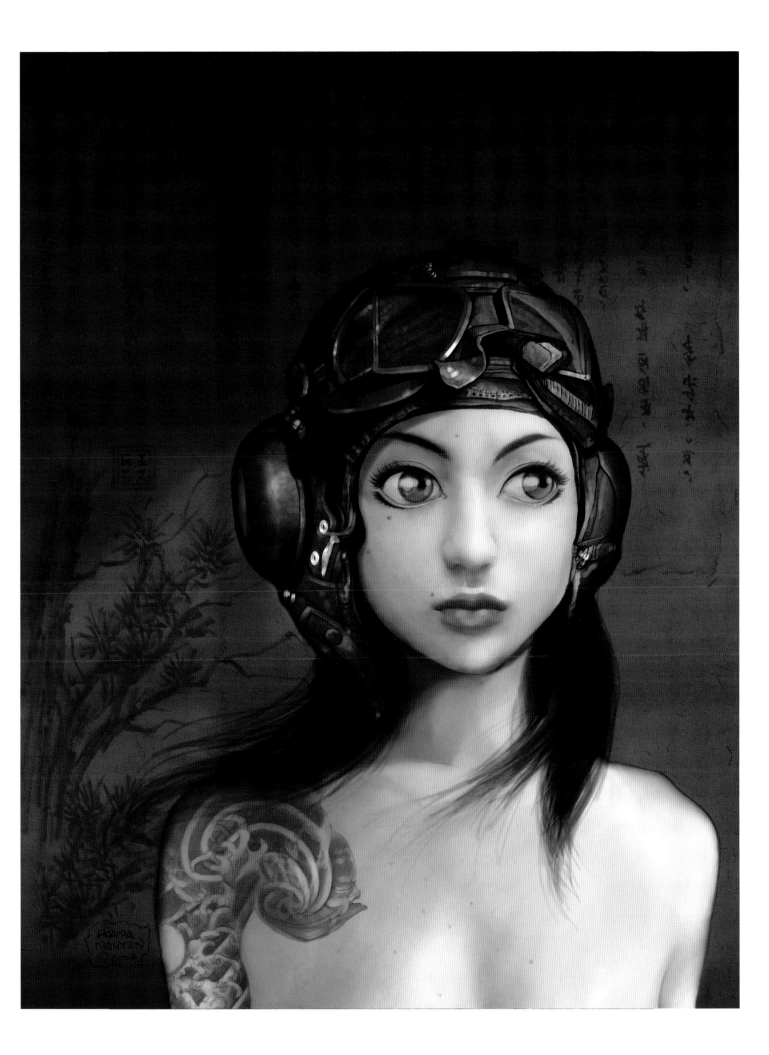

它在远处频频招手

快来，快来，

爱在切望等待，等待。

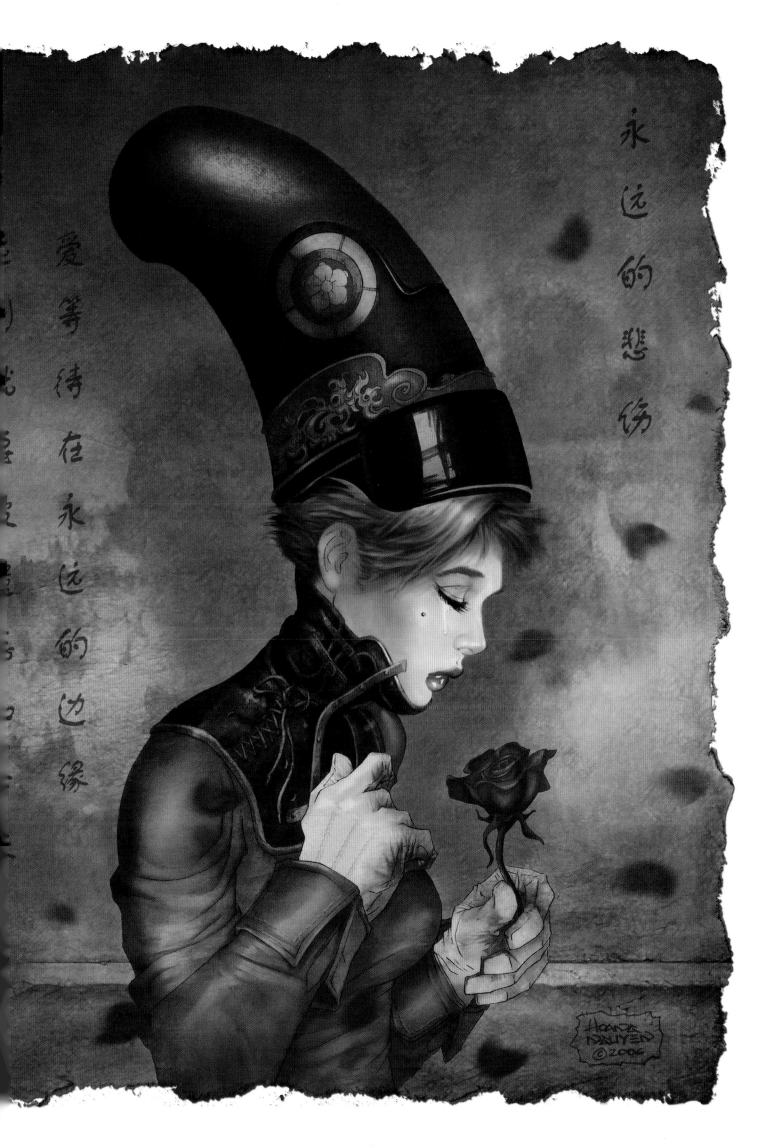

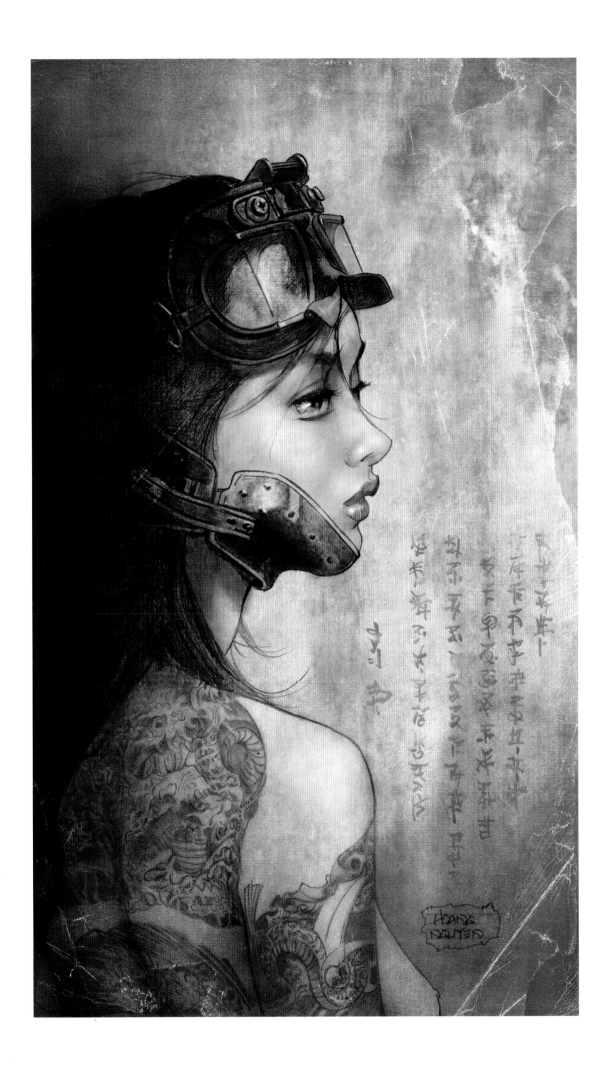

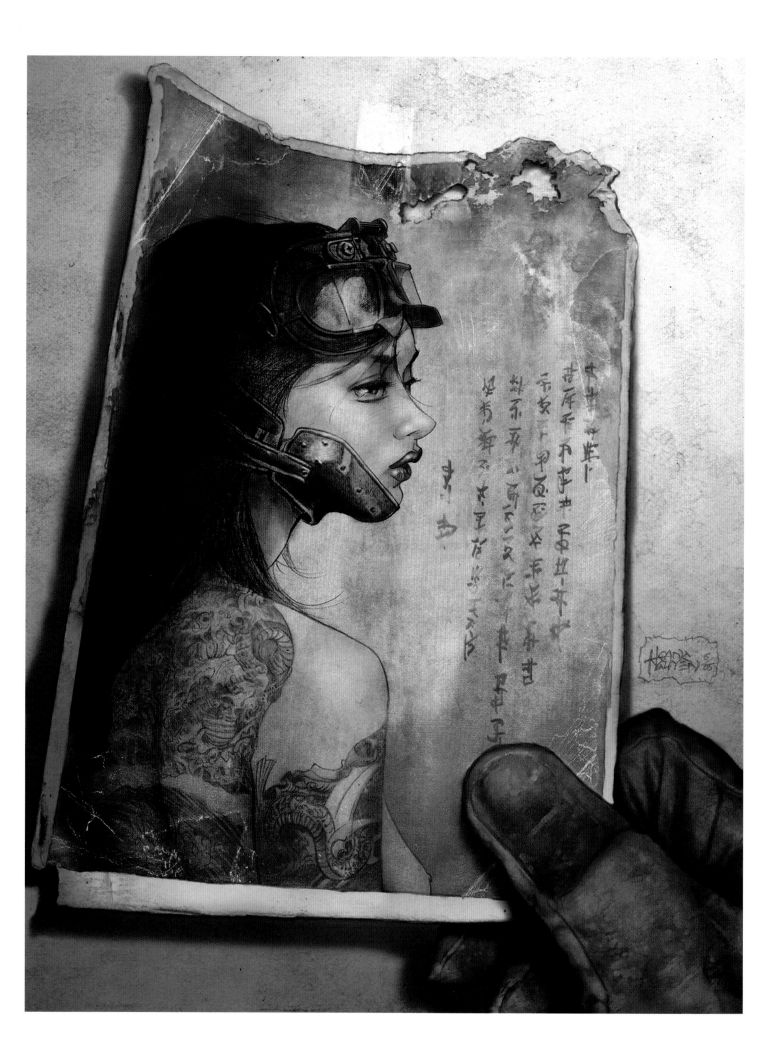

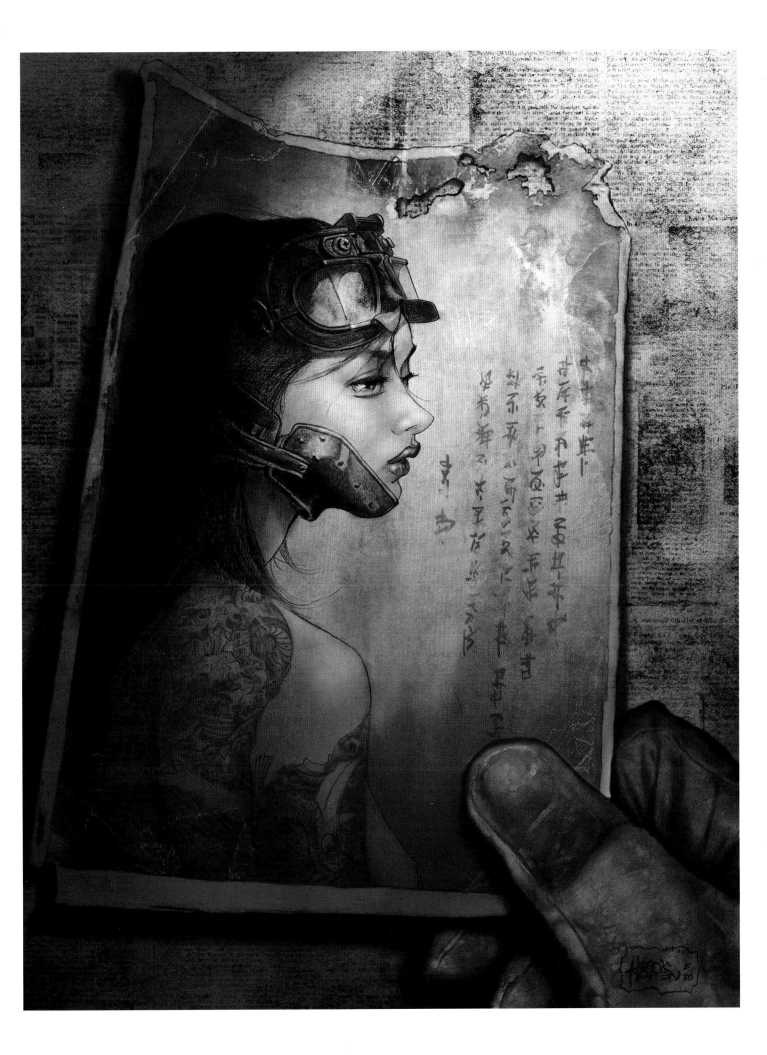

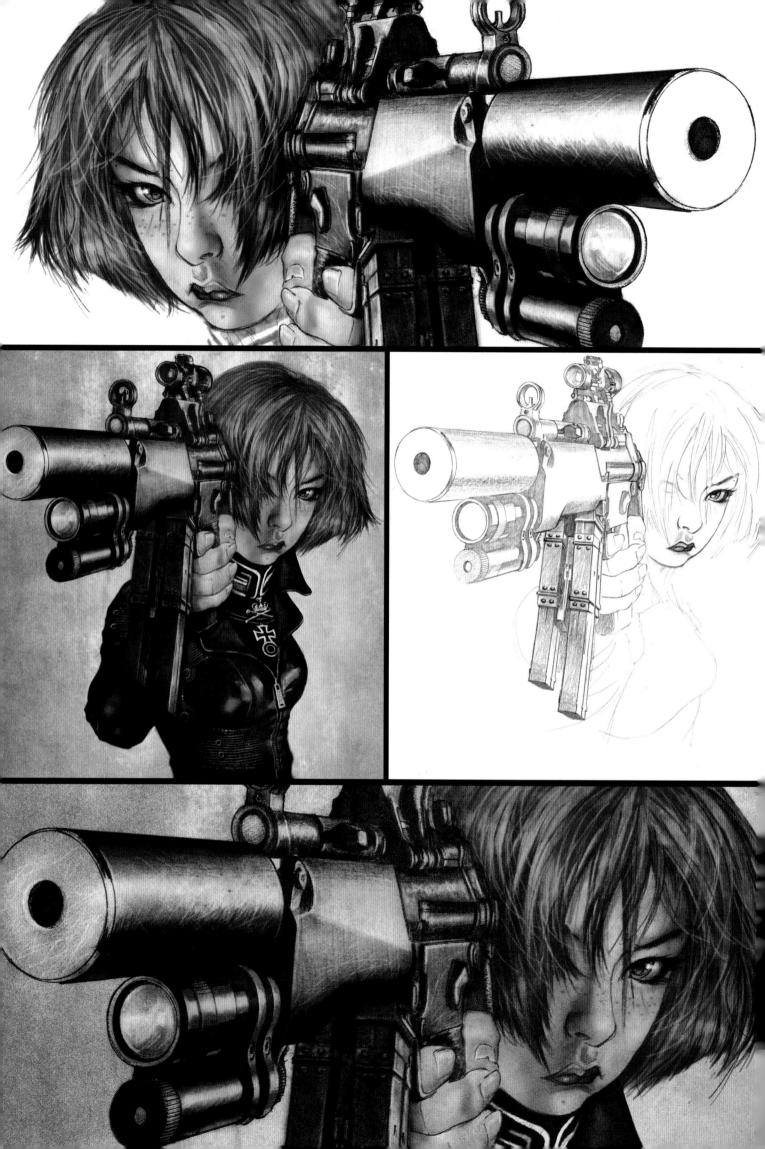

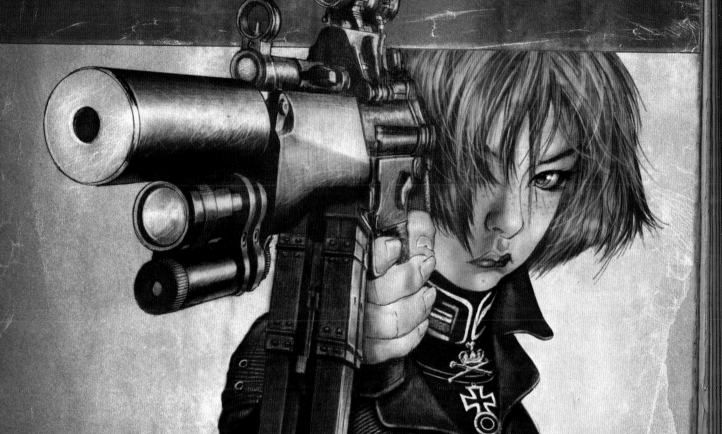

$10
Bucks

a Gun and Barrel Publication September

Hard Boiled to the Brink

DETECTIVE

MY BABY GONE BAD
Thrilling Love Triangle
by **Juno Black**

THE BIG BLACK HUSH
A Bizarre Crime novel
by **Kai Devin**

ONE BILLION BULLETS
Amazing Mystery Novel
by **Thai Dagan**

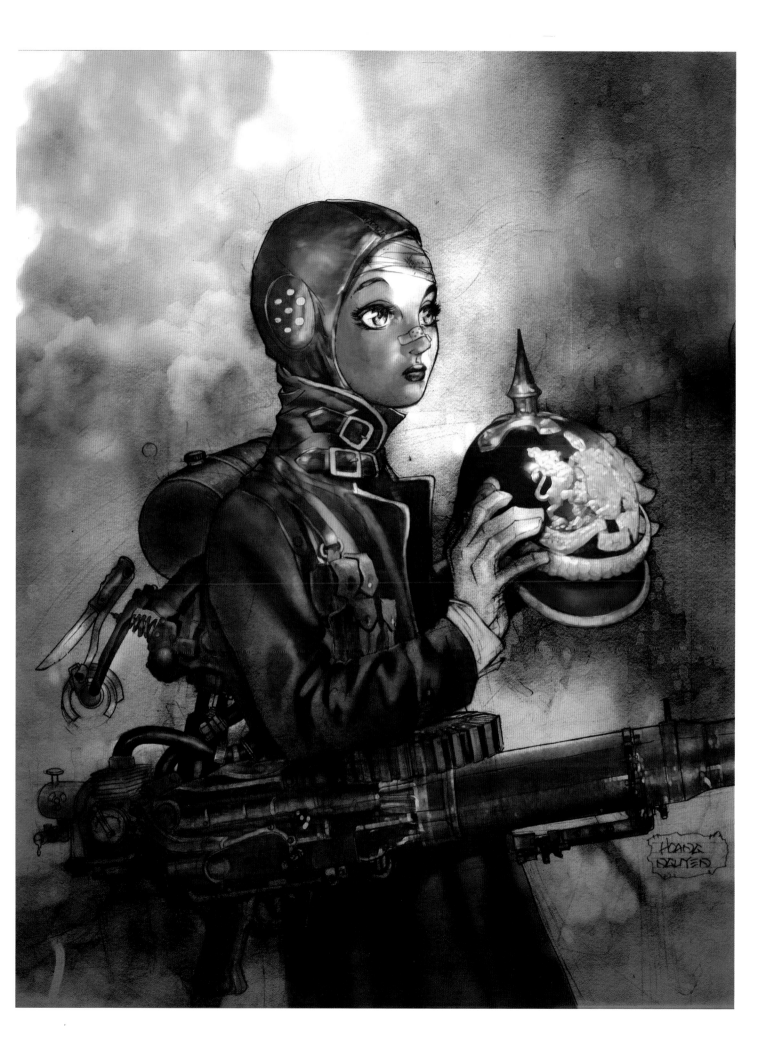

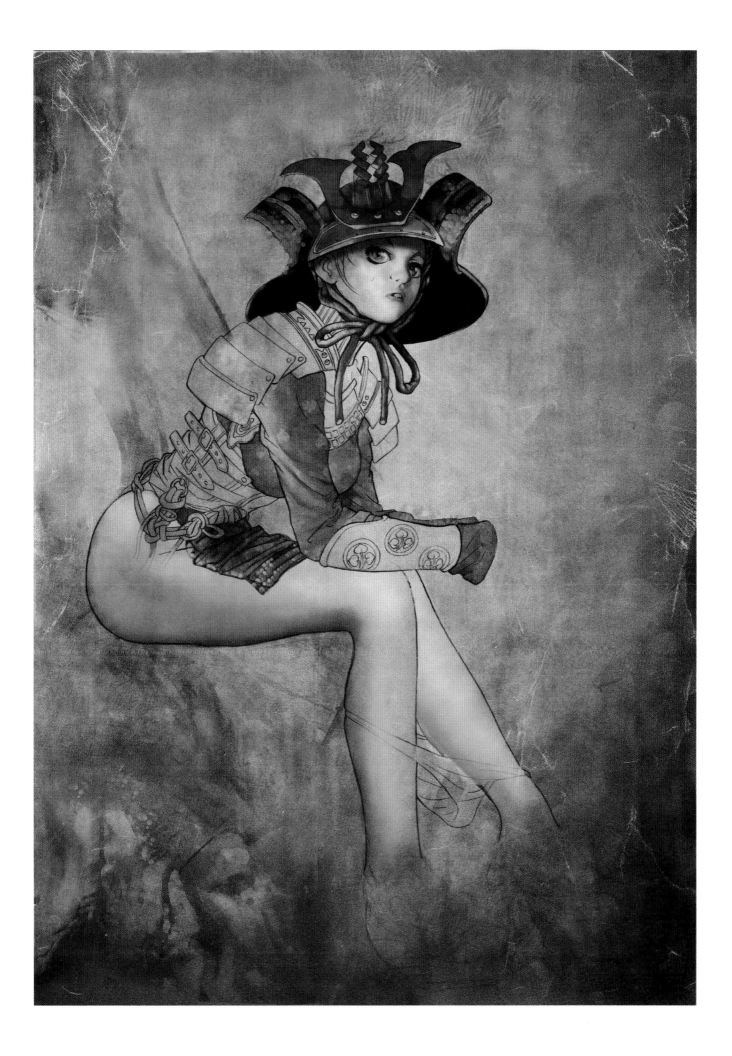

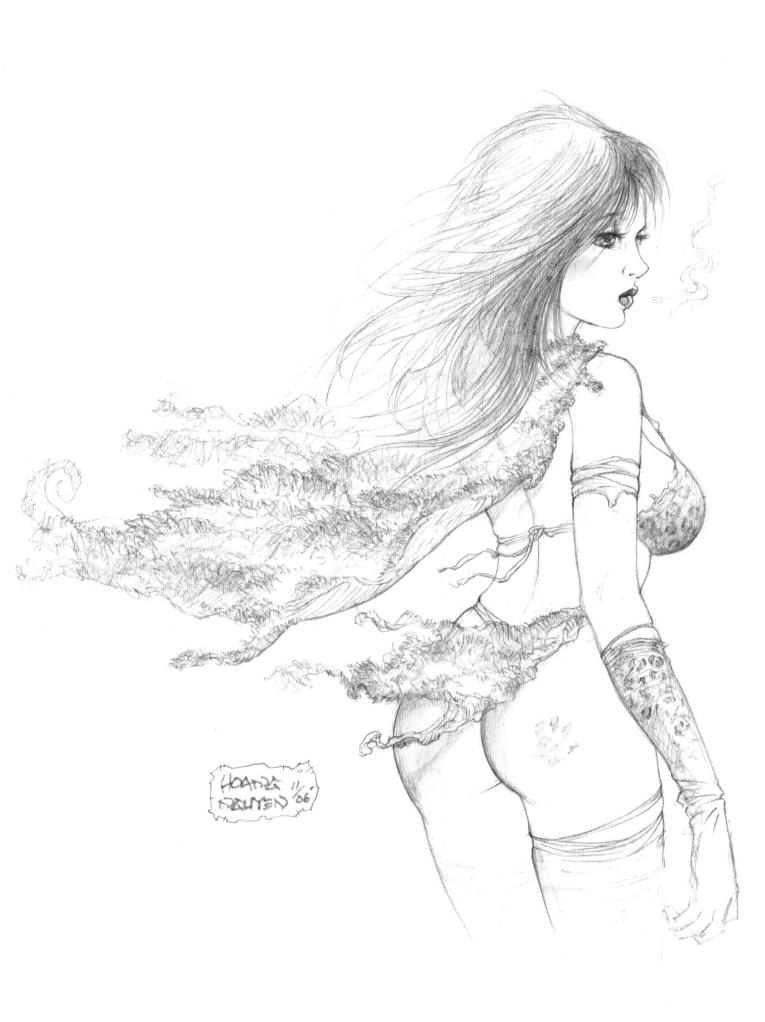

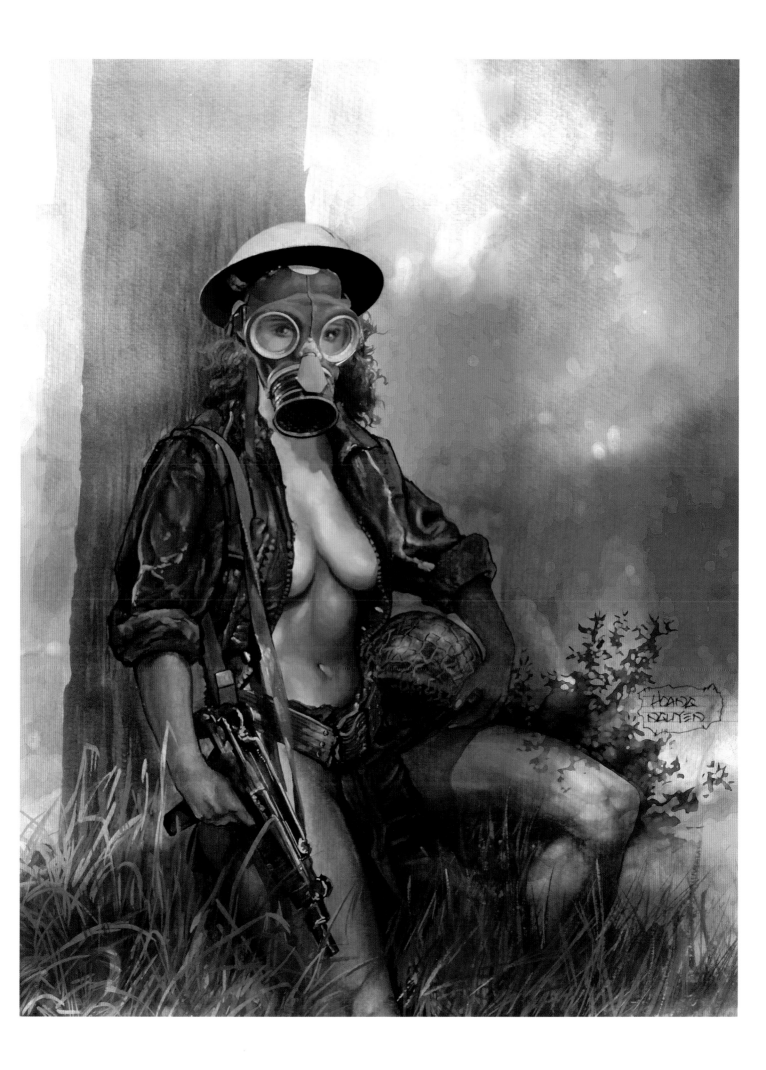

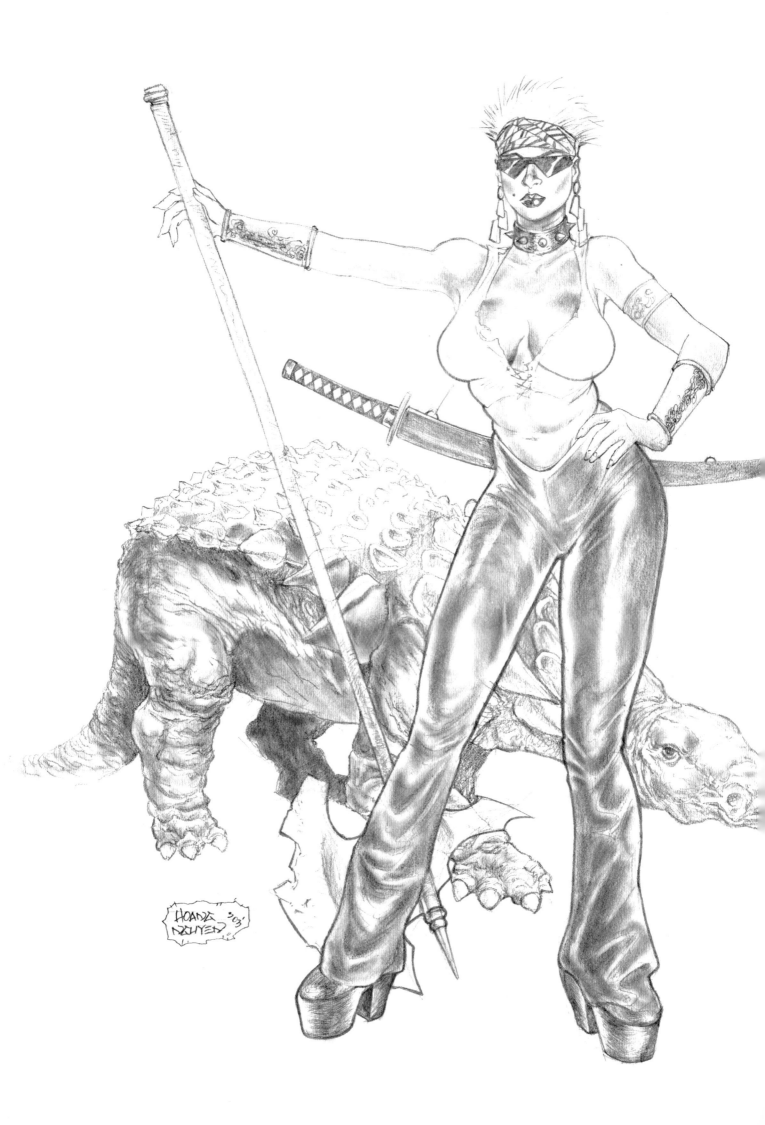

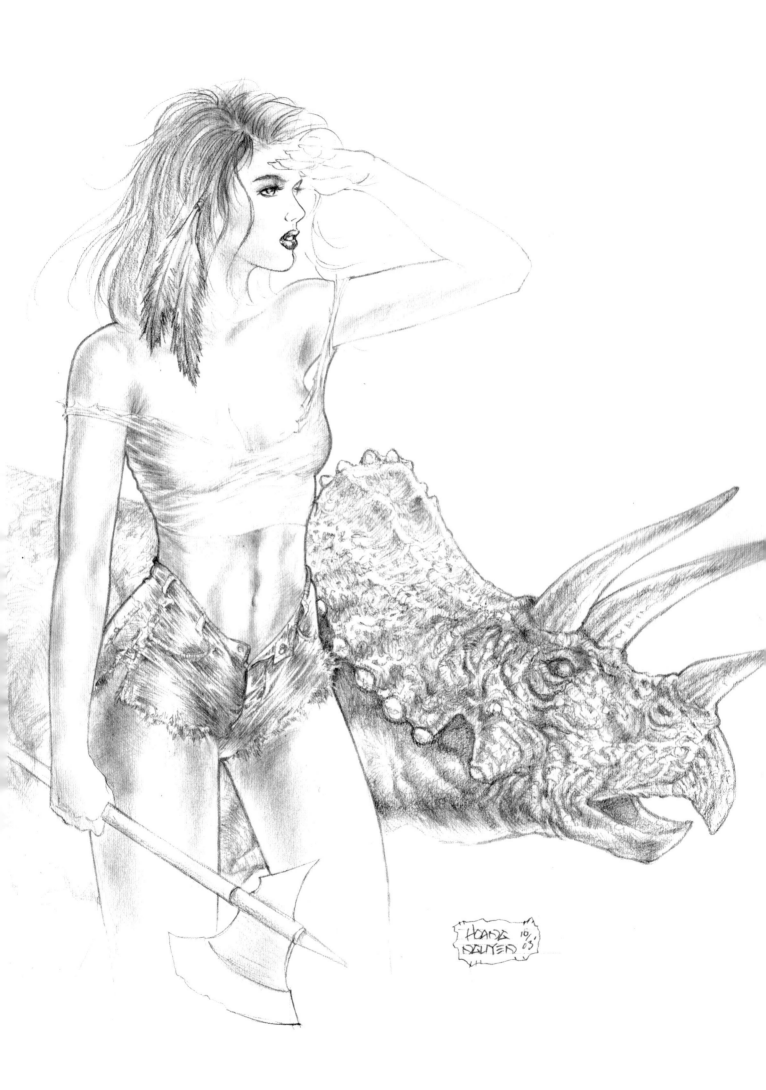

遠くから手招きして

来て、来て。

愛が待っているから、篤く、篤く。

やまびこは谷の間で響き

遠くからささやきが伝わってくる

涙と悲しみが溢れ出す

闇は全てを飲み込み

遠くから手招きして

来て、来て。

死が待っているから、熱く、熱く。

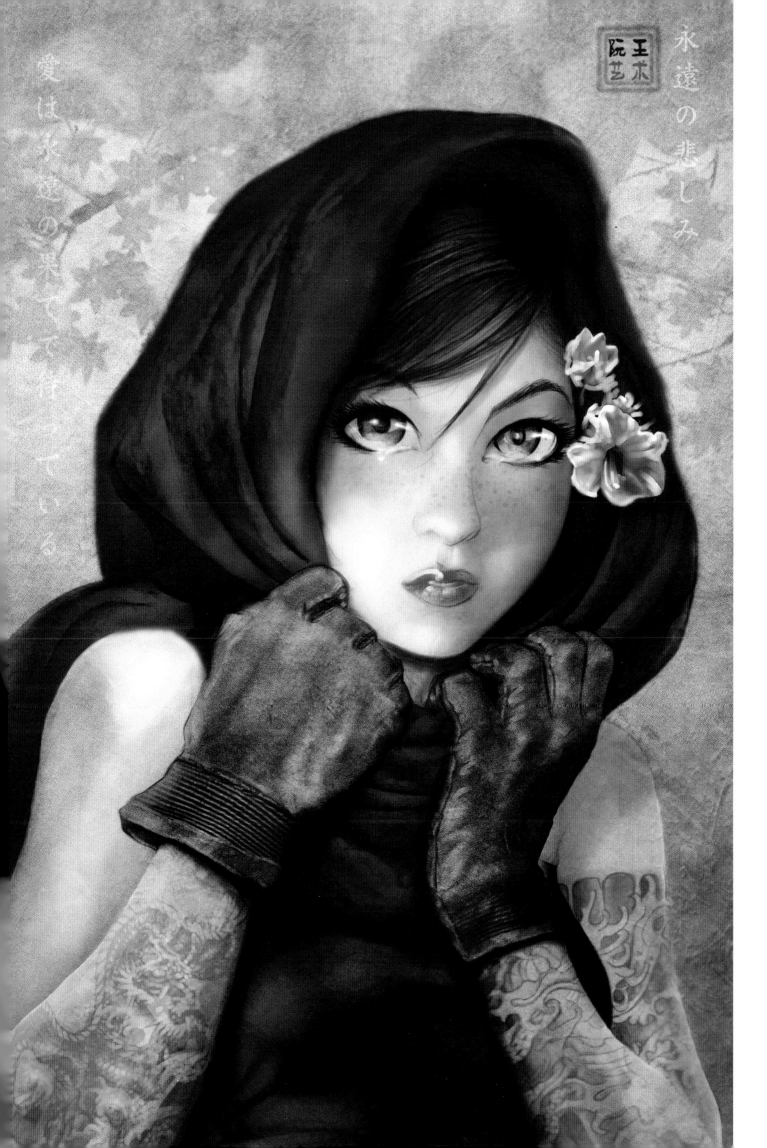

永遠の悲しみ
愛は永遠の果てで神わっている

王木
院芸

In 1994-95 I've created a comic book called "Metal Militia"
(copyright©1994-95 Hoang Nguyen)
It was about a para-military covert team, a group of super soldiers.
That handle the dirty works of the government.

At one point it was option for a major motion pictures by Dino DeLaurentis Co.
Presented here, re-colored and re-mastered for your viewing pleasure.

Hoang Nguyen 2007

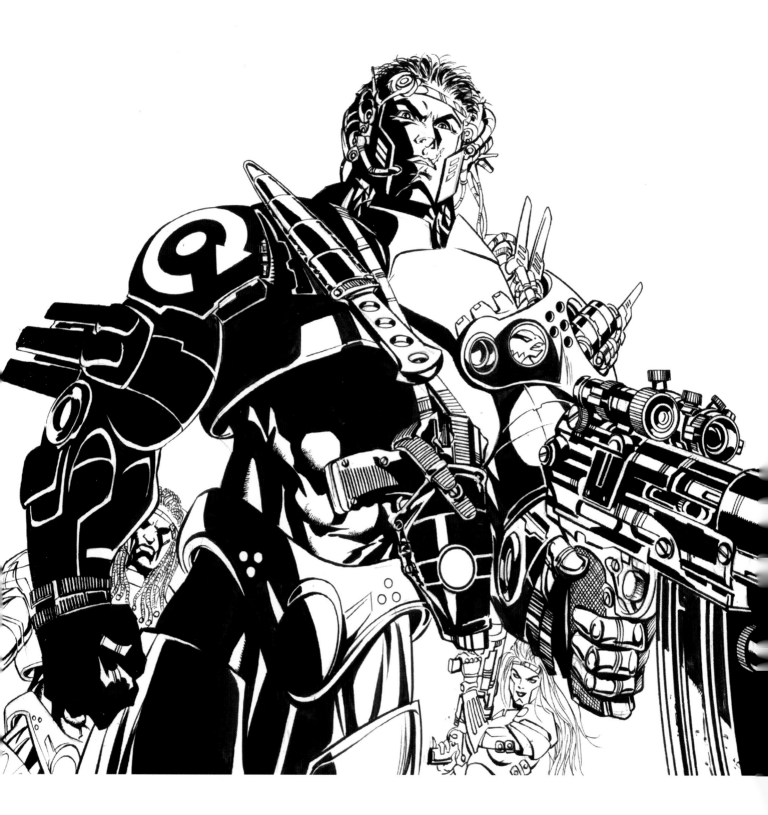

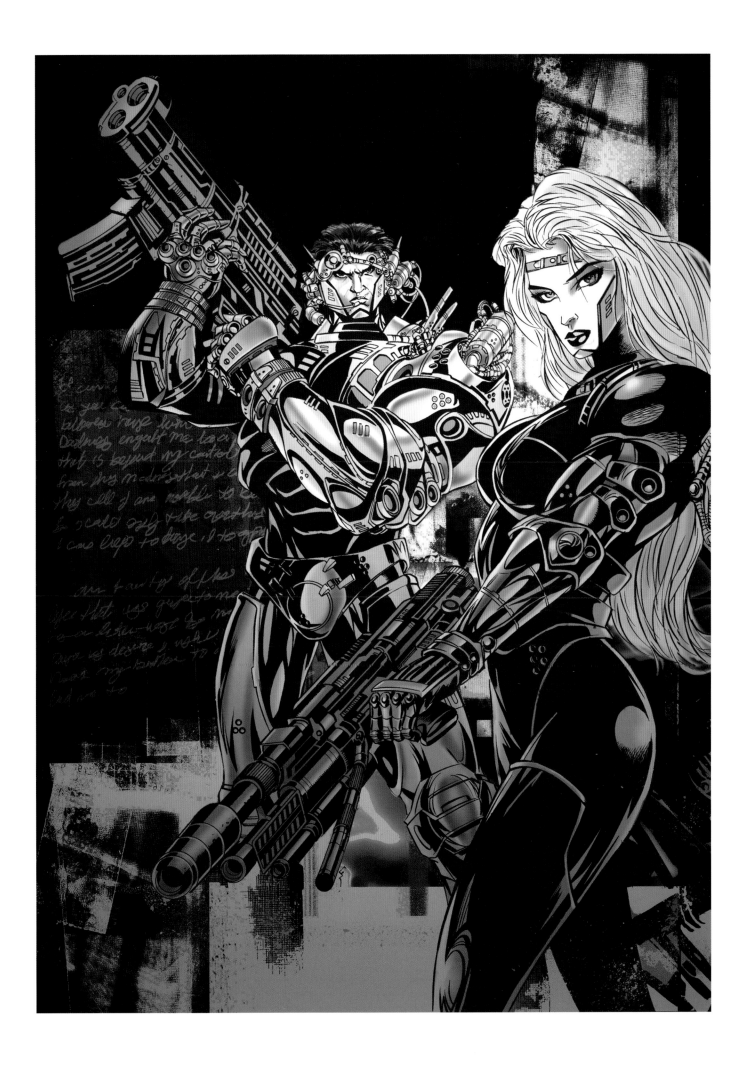

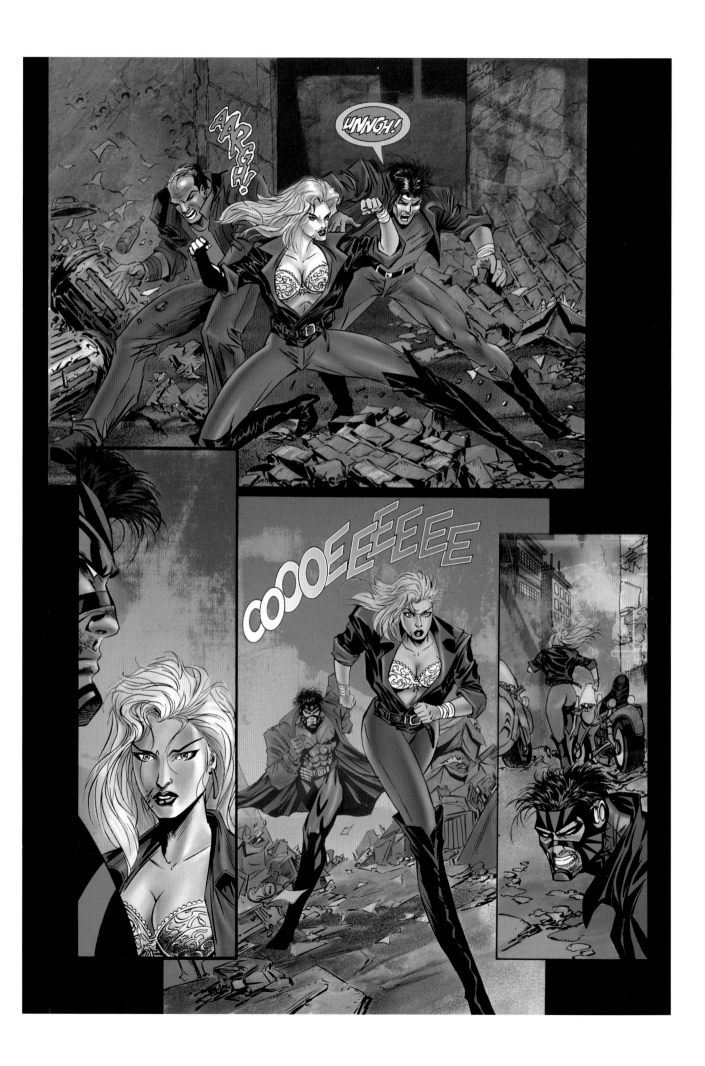

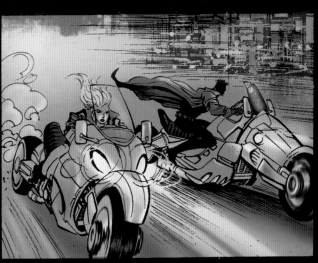
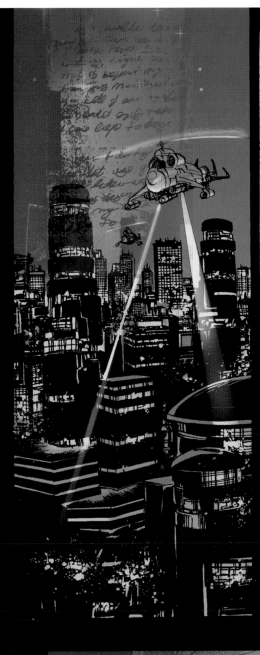
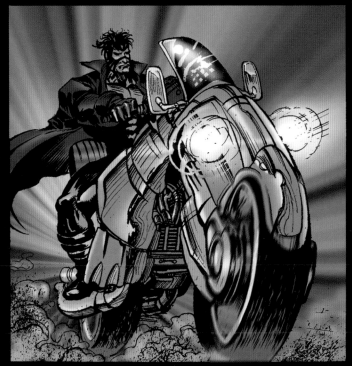
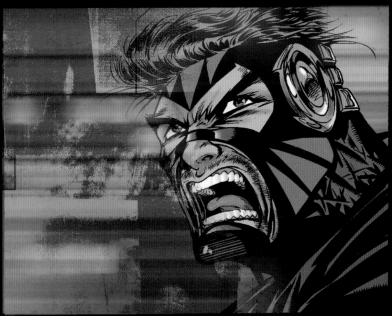
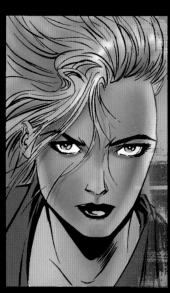

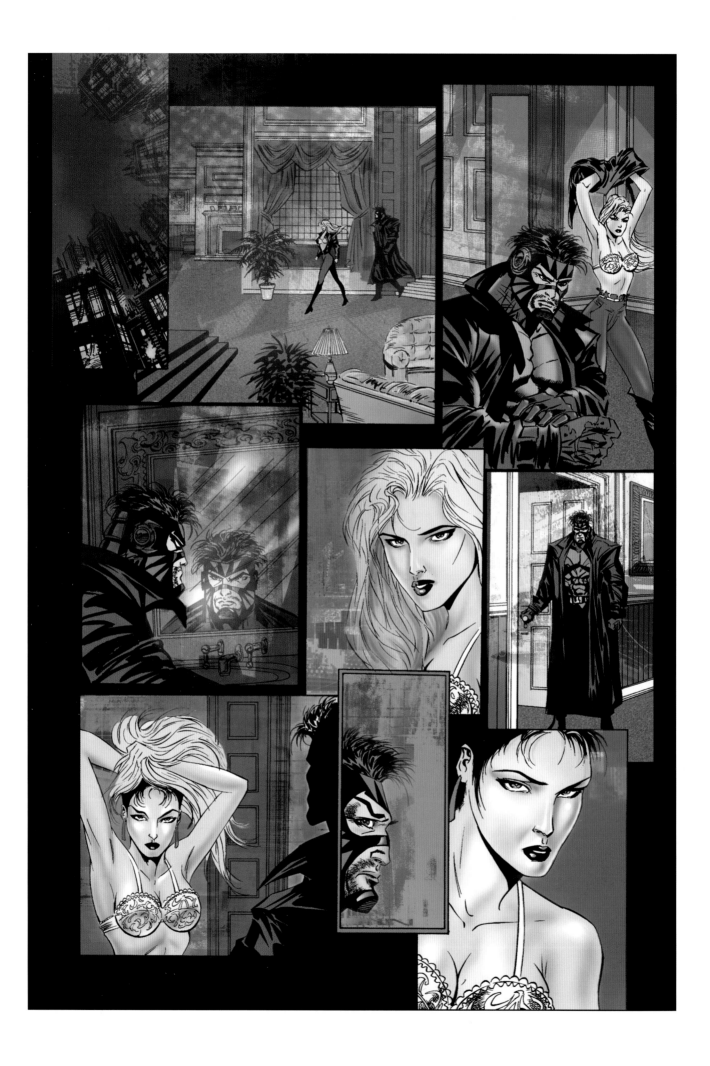

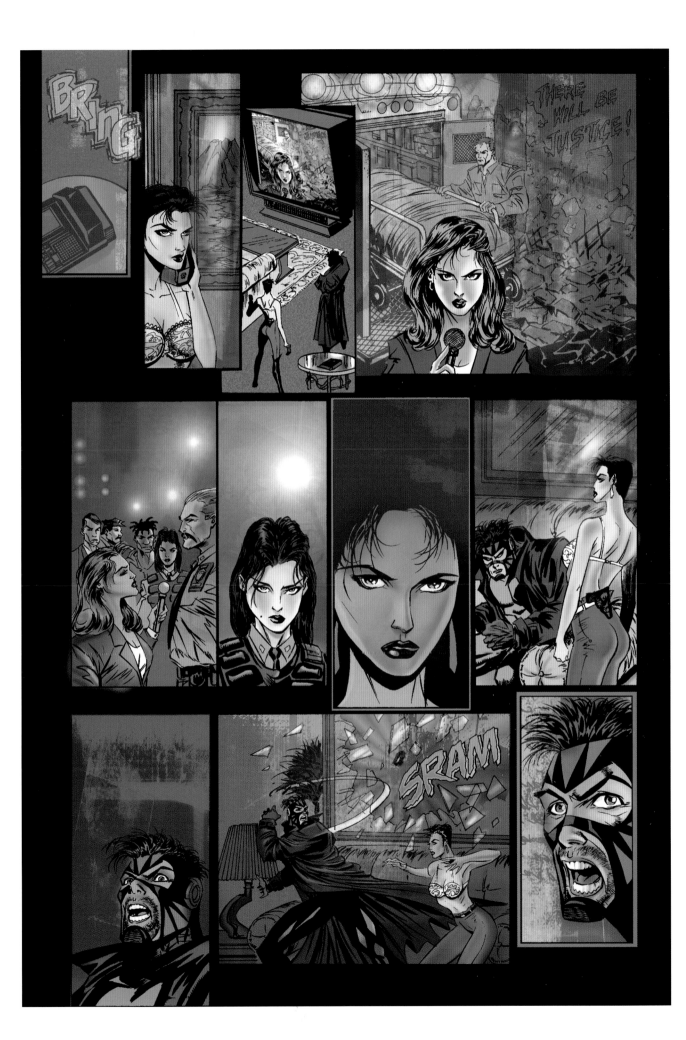

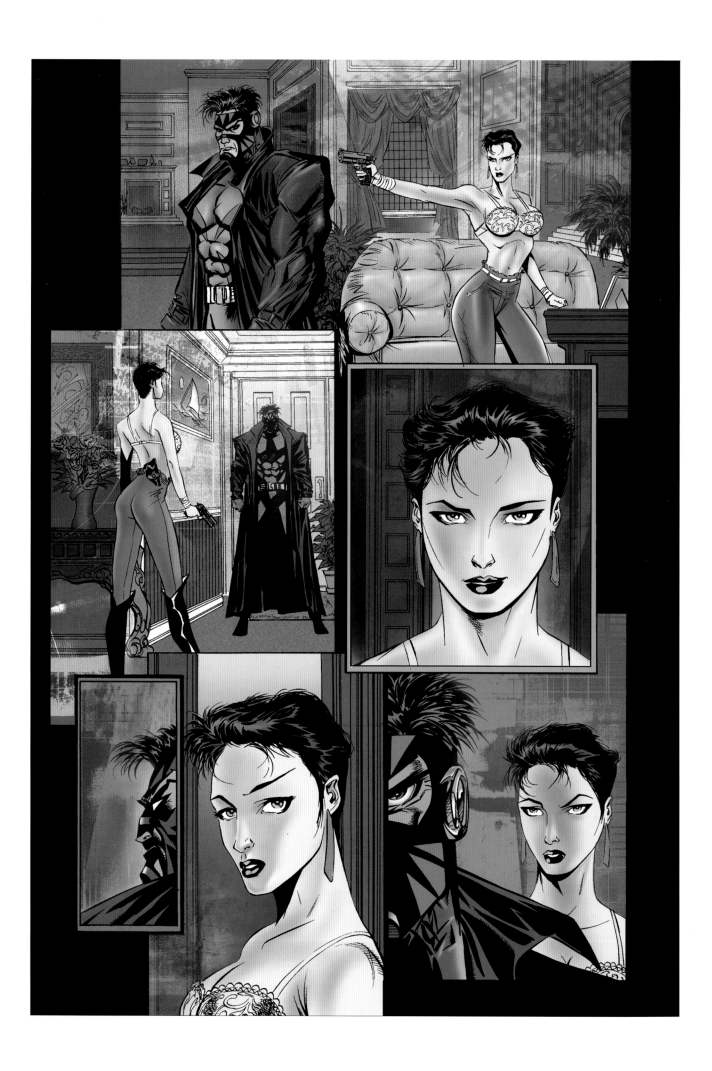

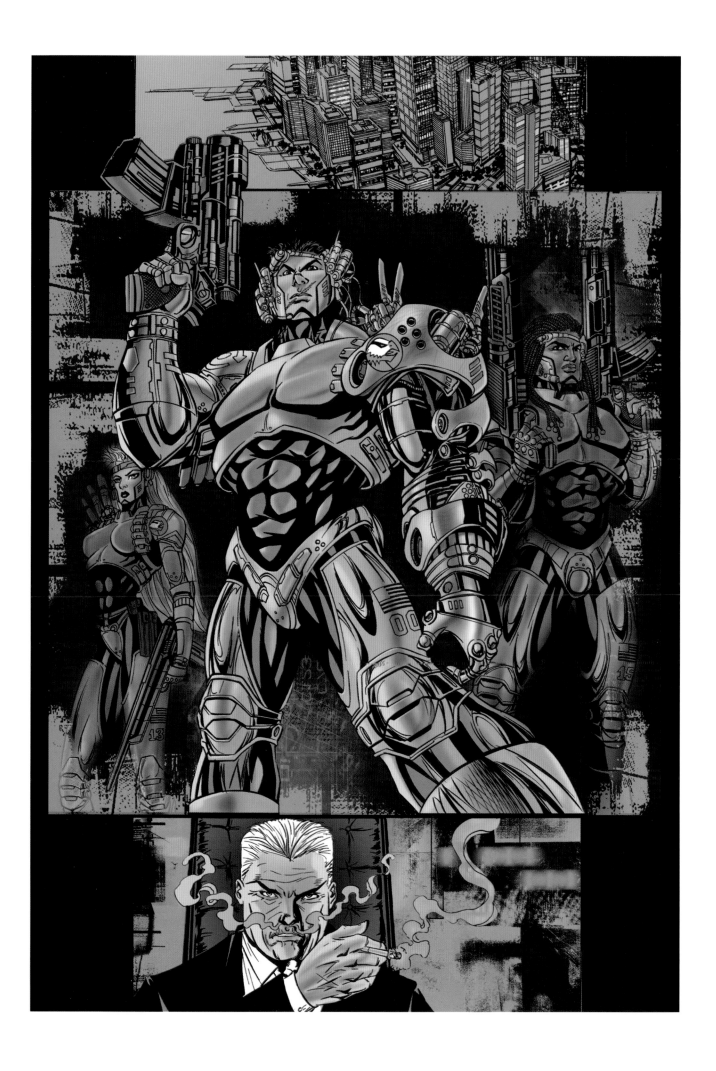

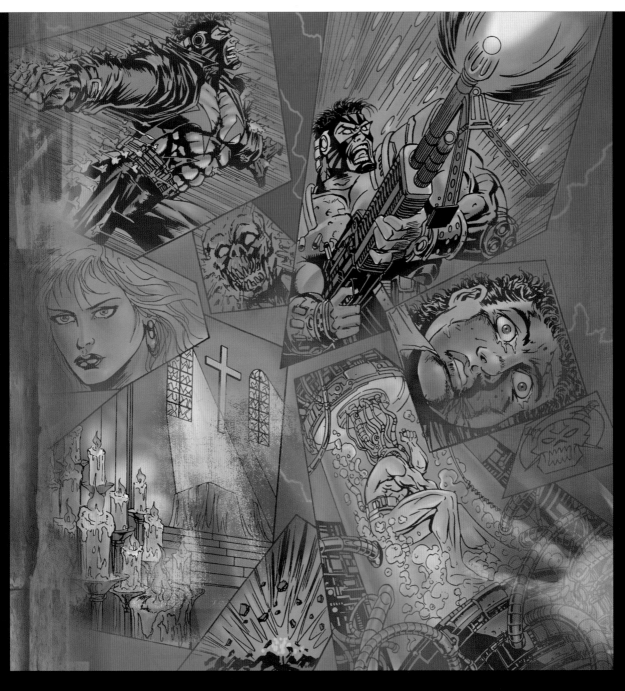

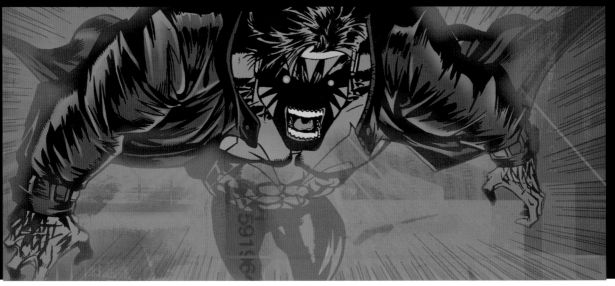

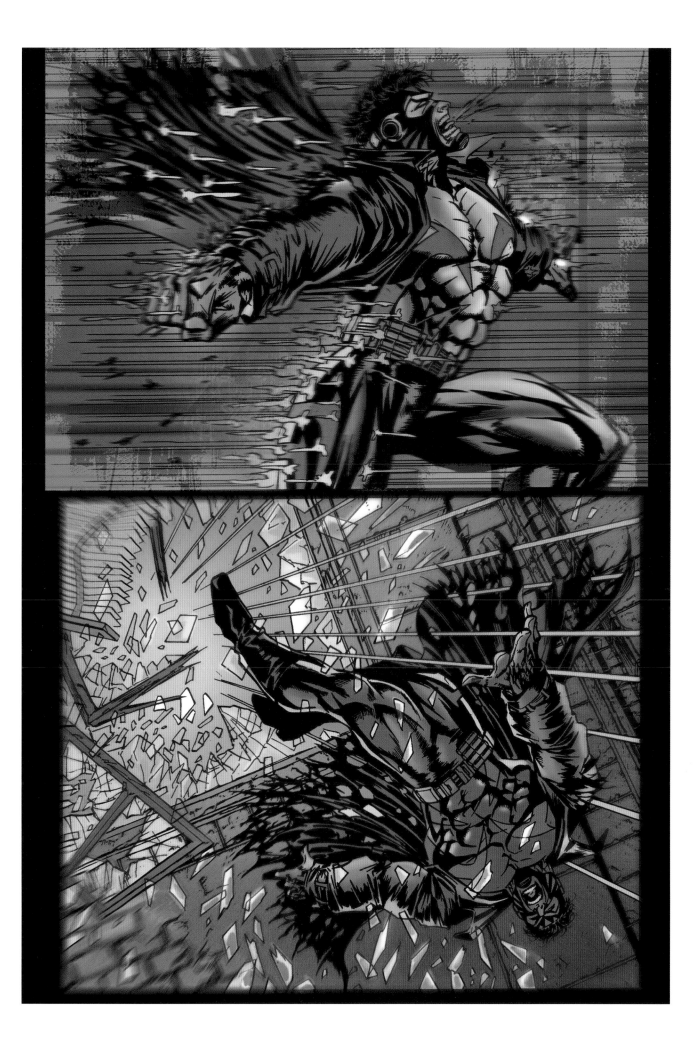

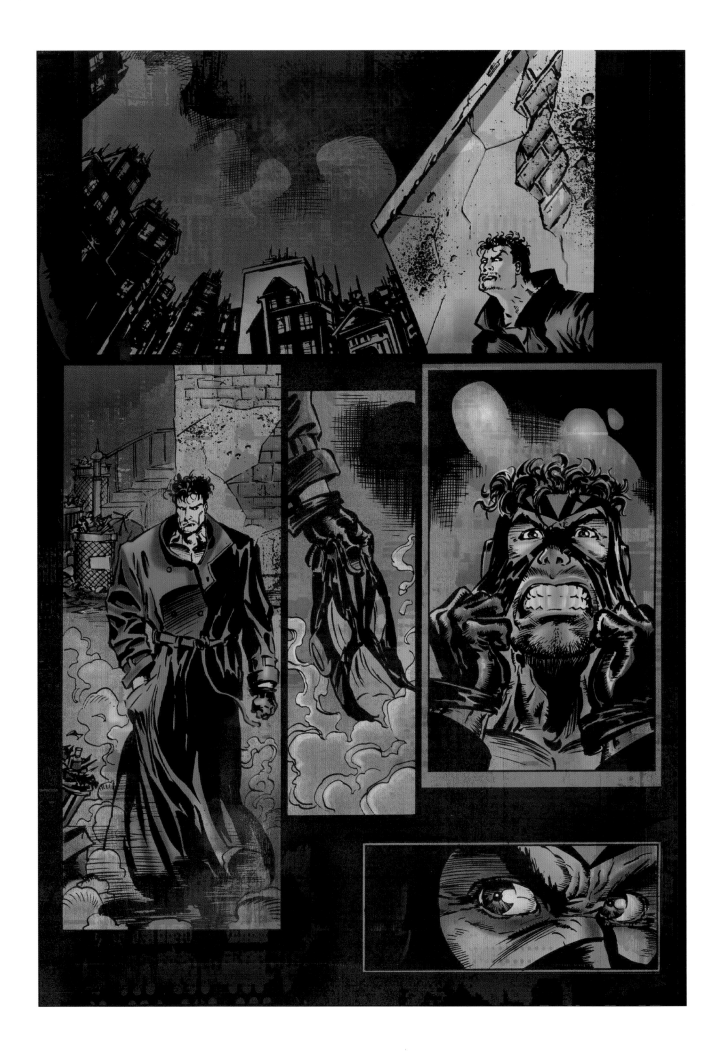

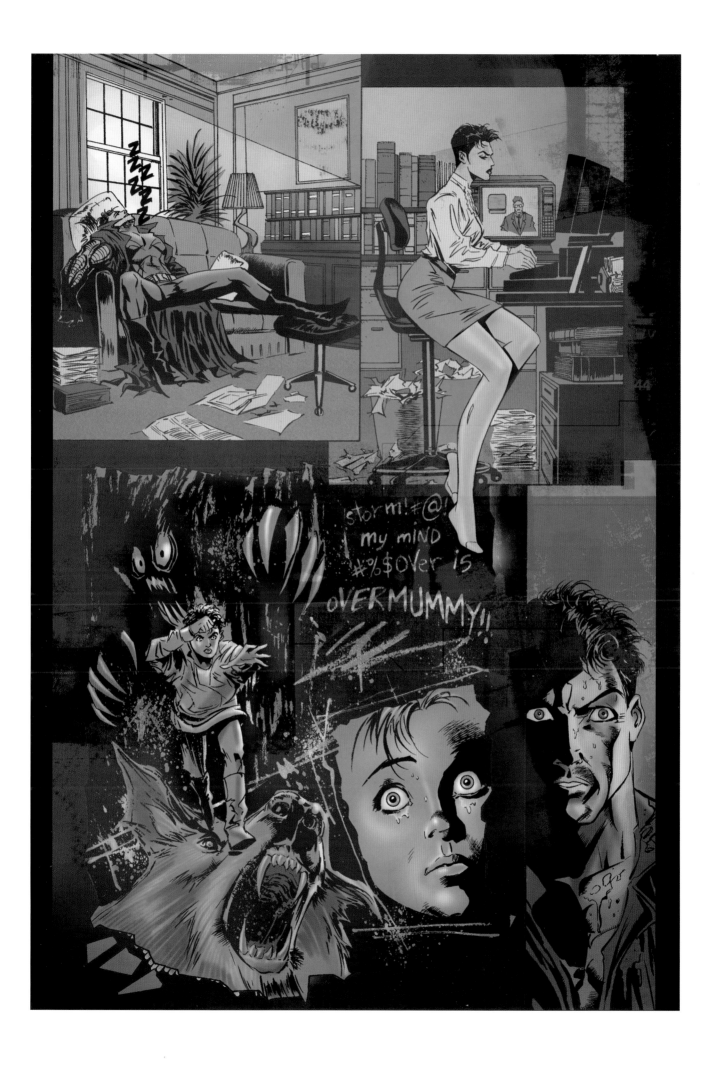

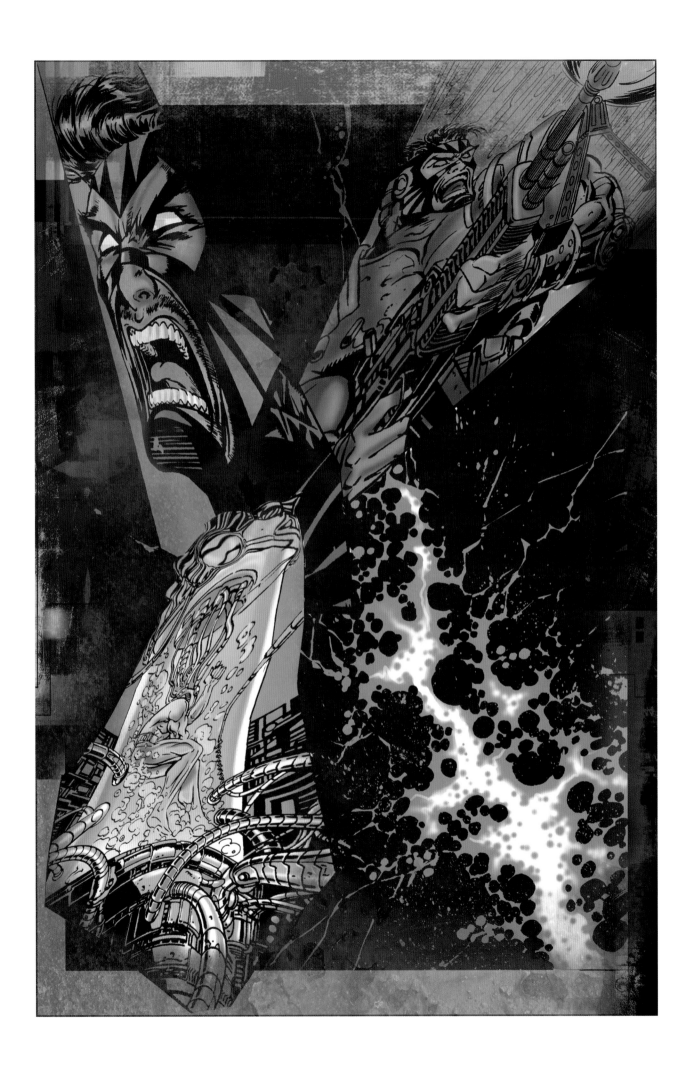

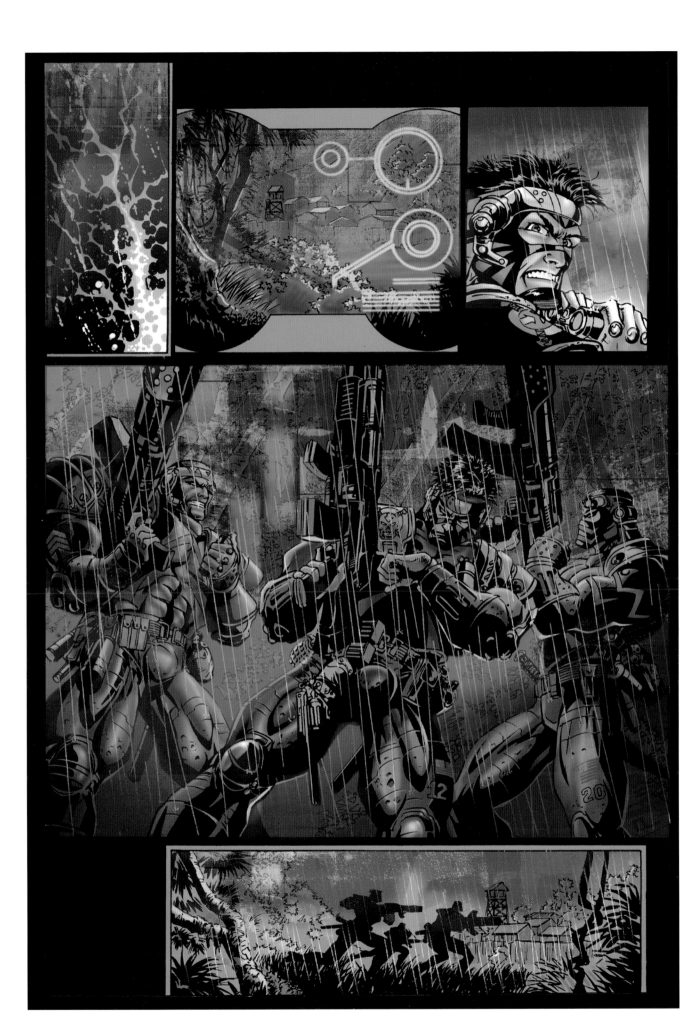

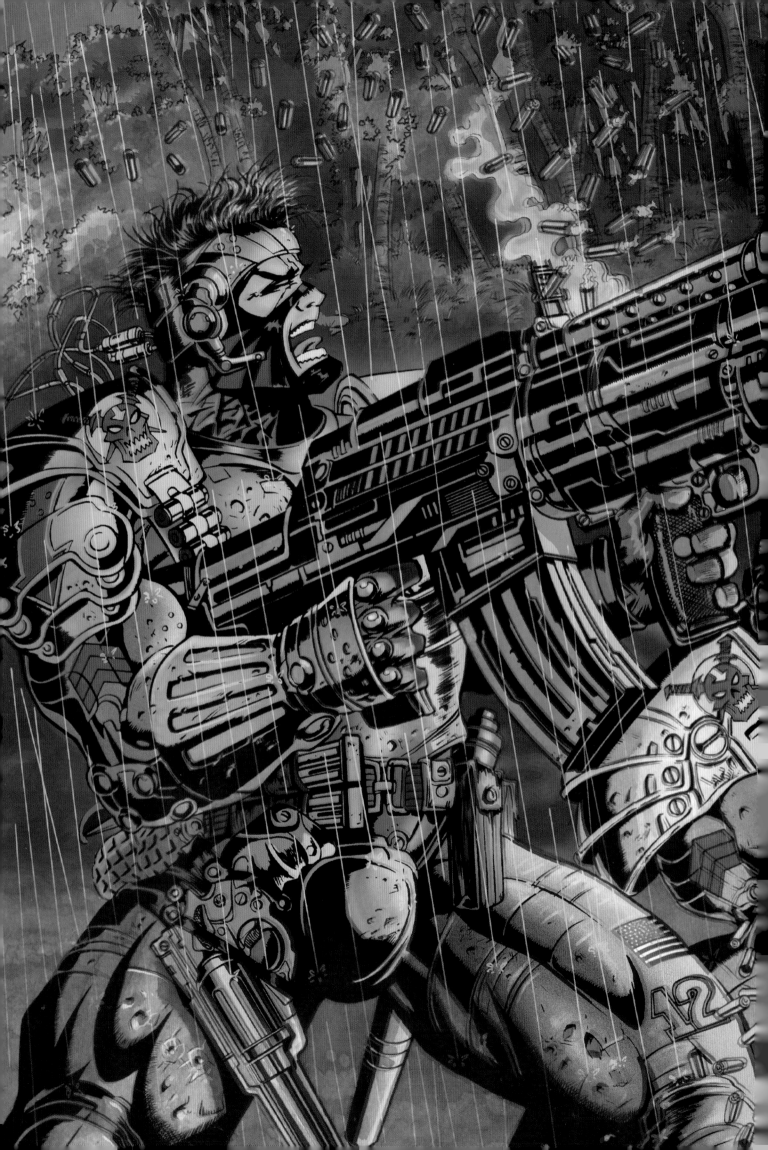

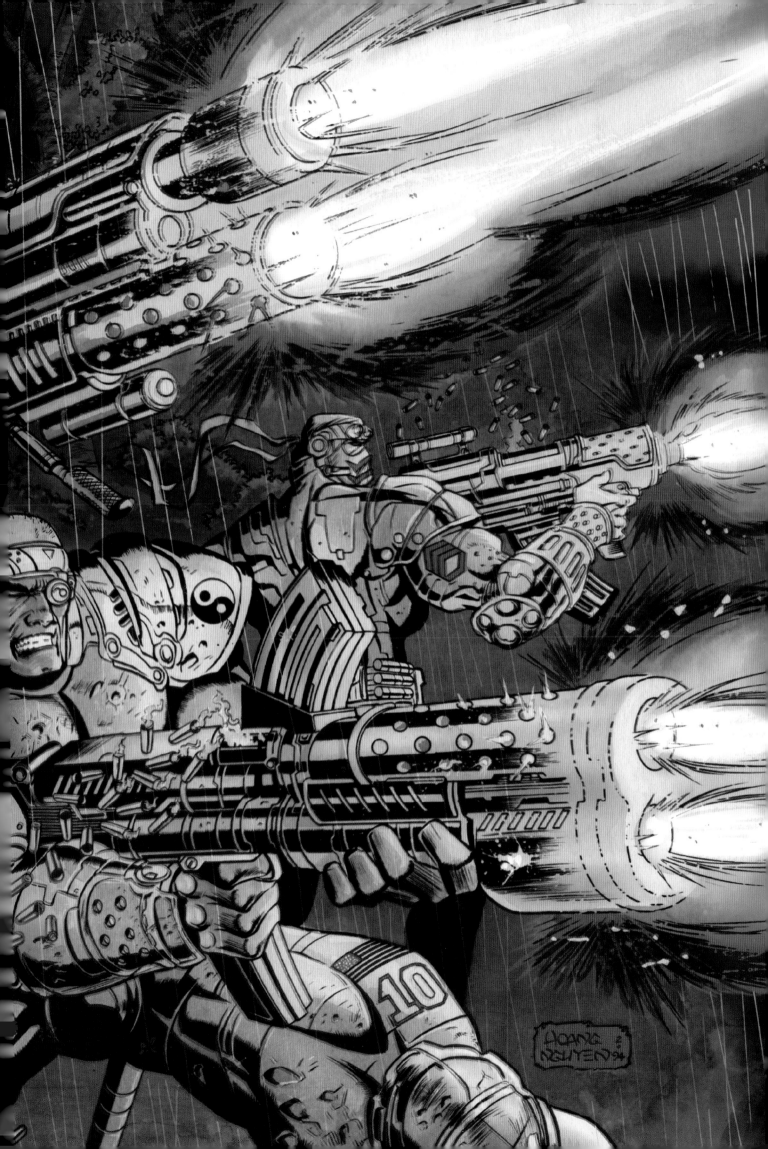

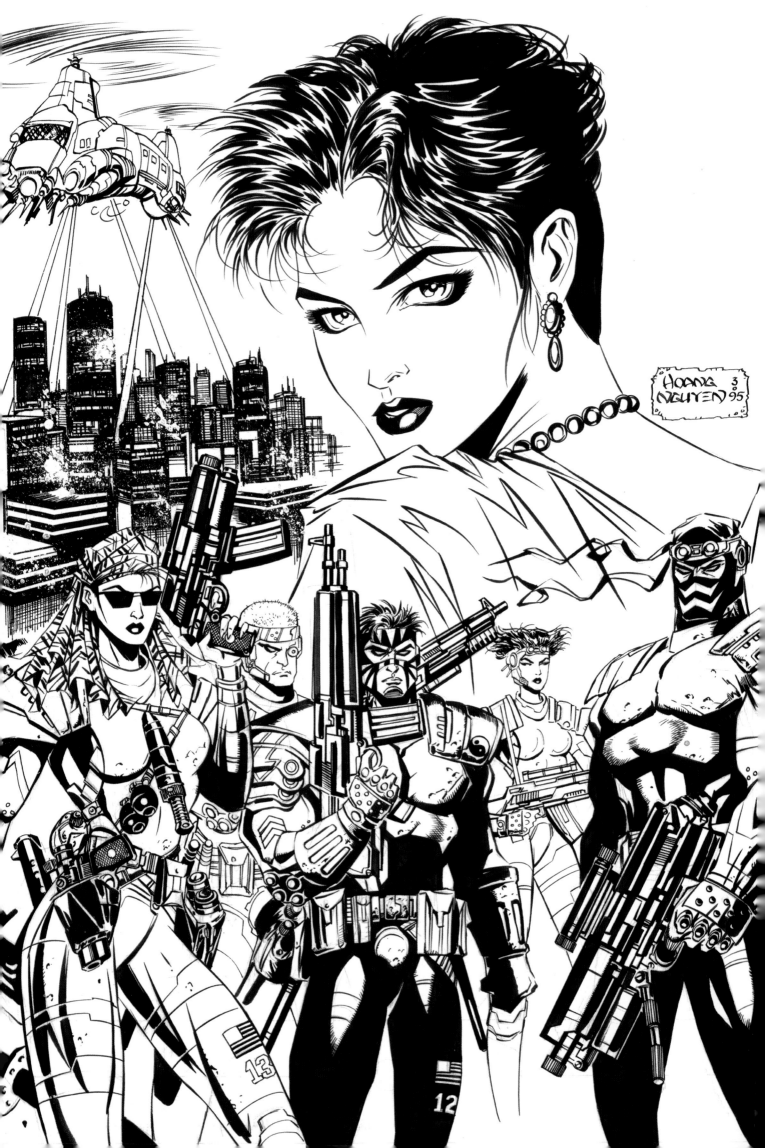

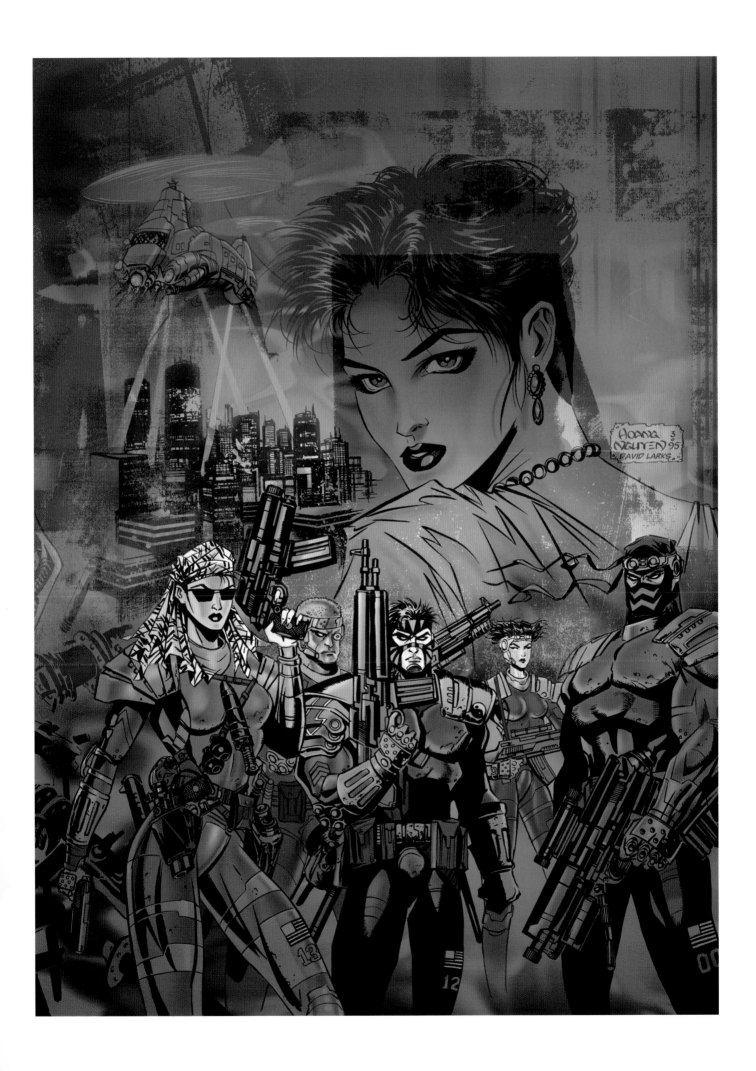

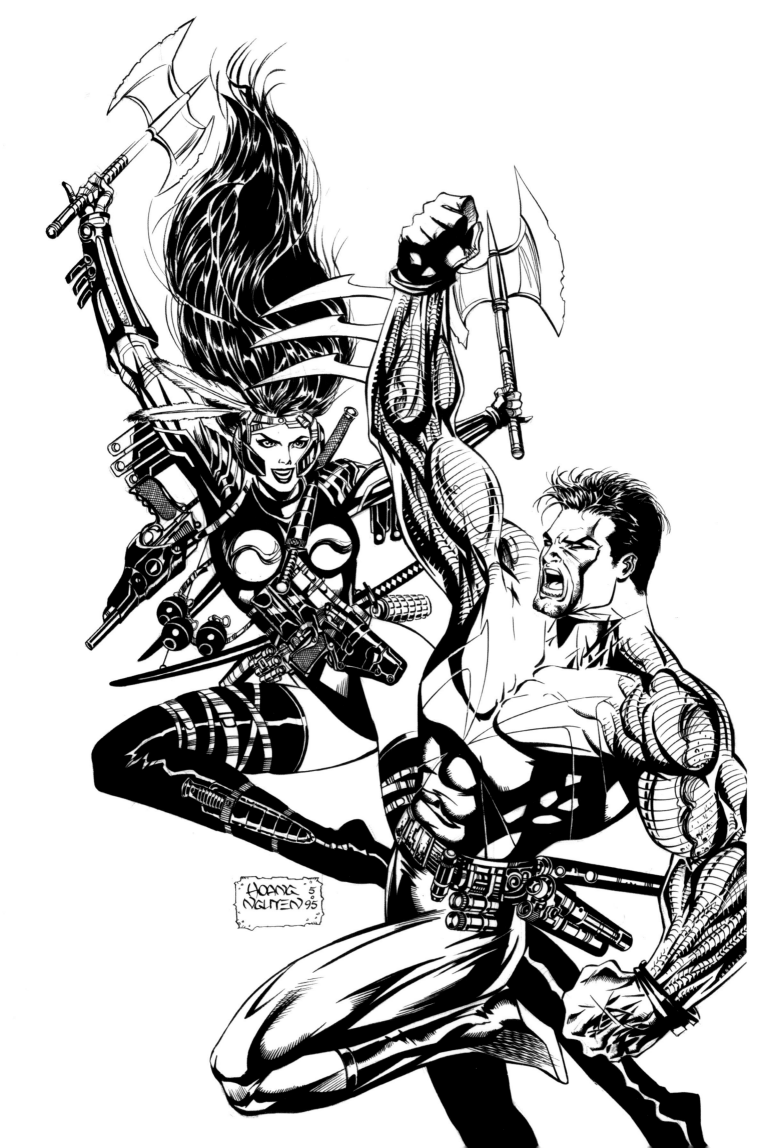

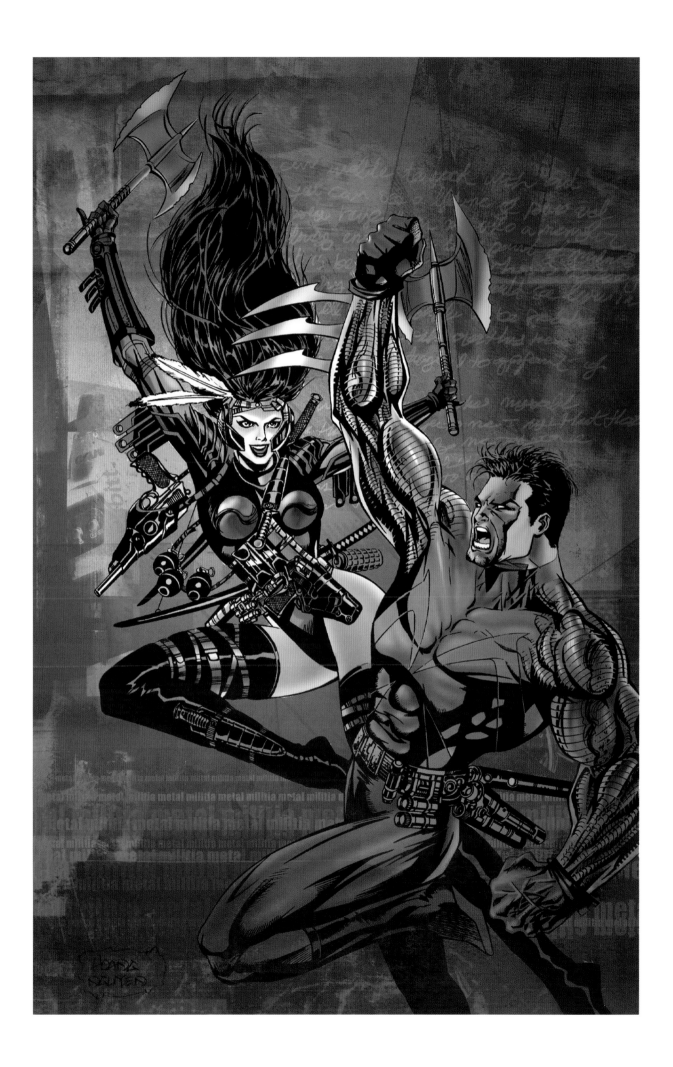

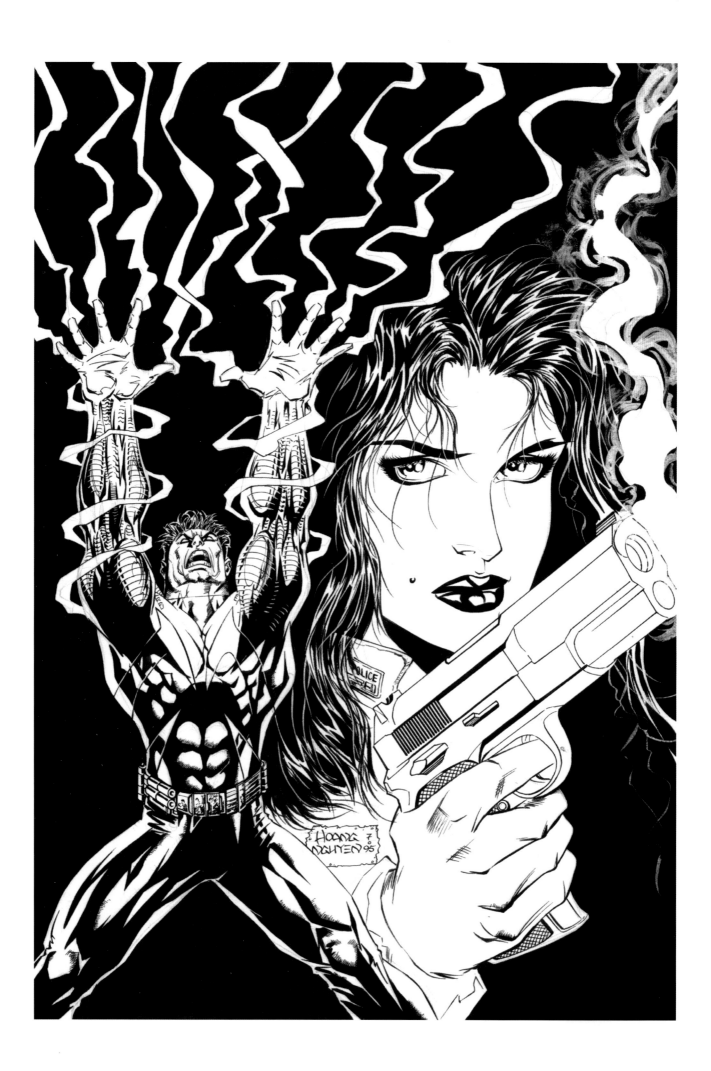

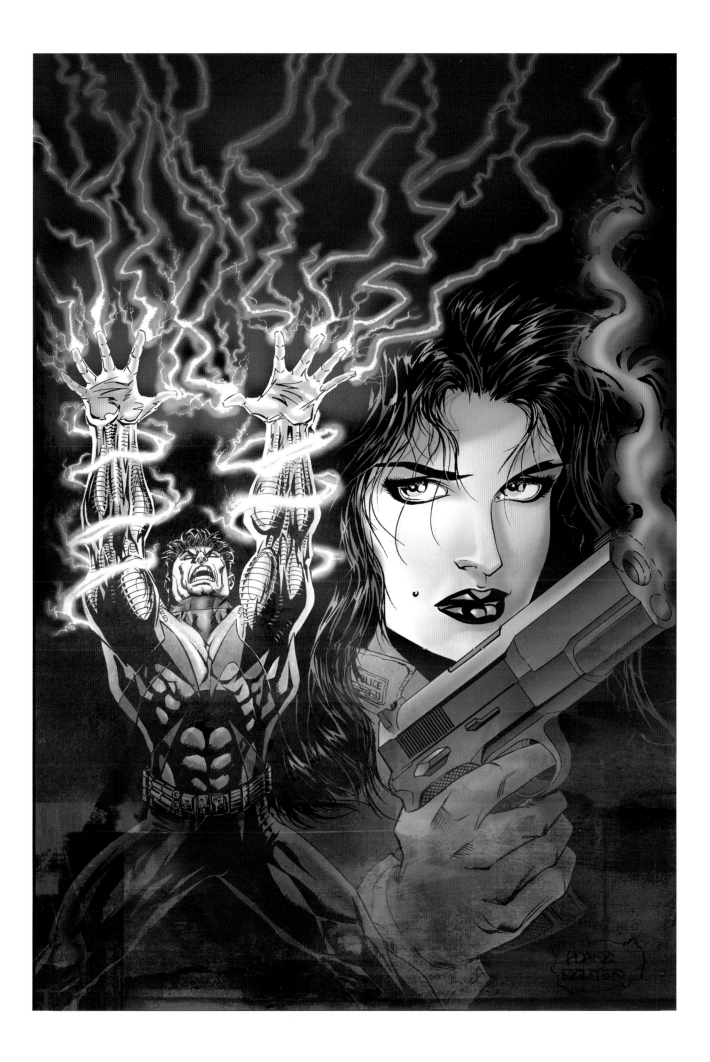

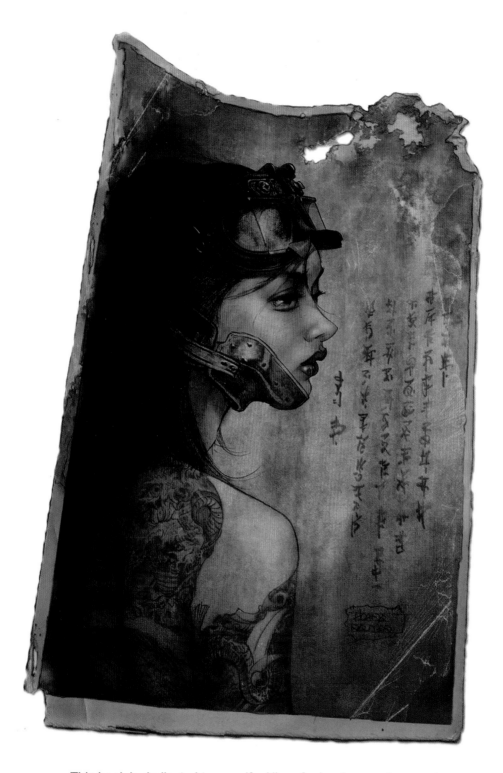

This book is dedicated to my wife, Nhan for her love and support

For Art book, posters and limited Giclee editions, visit:
www.liquidbrush.com

For all other inquiries, please e-mail Hoang Nguyen at:
Hoang@liquidbrush.com